# ✠ The Book of Signs ✠

# +The Book of Signs+

which contains all manner of
symbols used from the earliest times to the middle
ages by primitive
peoples and Early Christians

Collected, drawn and explained
by Rudolf Koch
Translated from the German
by Vyvyan Holland

✝

DOVER PUBLICATIONS, INC.

NEW YORK

*Standard Book Number: 486-20162-7*
*Library of Congress Catalog Card Number: 55-2433*

Manufactured in the United States of America

DOVER PUBLICATIONS, INC.
180 Varick Street
New York, N.Y. 10014

The illustrations
in this book
were once cut on wood by Fritz Kredel,
Offenbach am Main
*
The copies of this book
have been printed in Professor
Rudolf Koch's magere deutsche type.

# Note

Students of modern printing will be aware that Rudolf Koch is an outstanding personality in the modern devel= opment of the graphic arts in Germany, and has achieved fame as a type=designer, calligrapher, artist and book= binder.     :     :     :     :     The present translation of his Book of Signs contains 493 symbols, used from ancient times up to the middle ages, which have been collected by Koch and his friends from carvings, inscriptions and manuscripts. Among them are Byzantine monograms, the signs of the Cross, the Holy initials, stonemason's signs, the signs of the four elements, and botanical, astrological and chemical signs. They have been redrawn and explained by Rudolf Koch himself, and cut on wood by Fritz Kredel. As readers will readily see, they have, in their present form at least, visual as well as symbolic beauty.

A. J. A. Symons

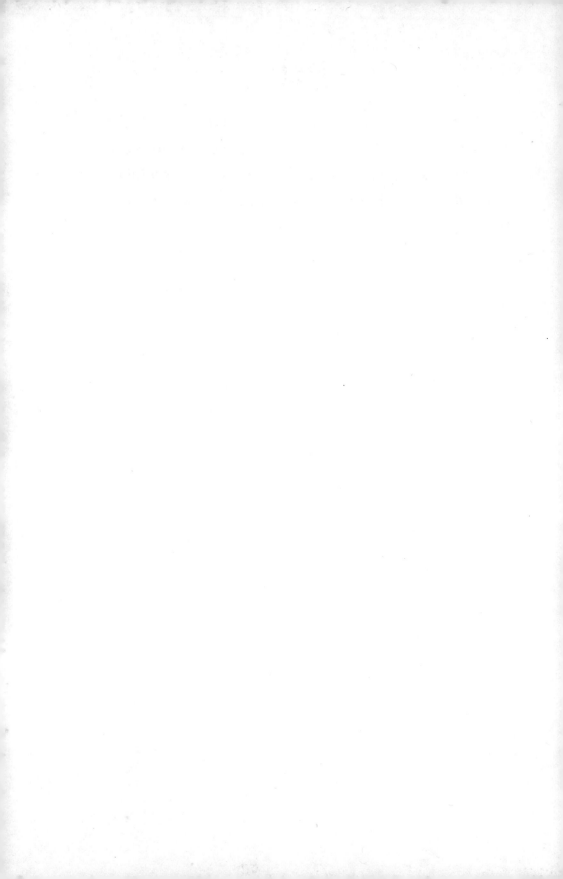

# 1. General signs.

The dot is the origin from which all signs start, and is their innermost essence. It was with this idea that the Masonic lodges of old expressed the secrecy of their guilds by means of the dot.

In the horizontal stroke, on the other hand, we see the Earth, in which life flows evenly and everything moves on the same plane.

The vertical stroke represents the one-ness of God, or the Godhead in general; it also symbolizes power descending upon mankind from above, or, in the opposite direction, the yearning of mankind towards higher things.

The angle, or the meeting of the celestial and the terrestrial. As they possess nothing in common, they touch, but do not cross one another. This sign represents the reciprocation between God and the World. In Masonic lodges of the Middle Ages the right angle was the sign of Justice and Integrity.

1

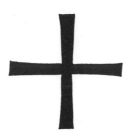

In the sign of the Cross God and Earth are combined and are in harmony. From two simple lines a complete sign has been evolved. The Cross is by far the earliest of all signs, and is found everywhere, quite apart from the conception of Christianity.

The open eye of God, the purpose of Revelation: "And God said, Let there be light."

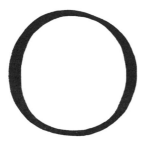

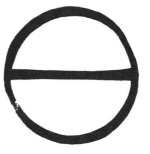

The circle, being without beginning or end, is also a sign of God or of Eternity. Moreover, in contrast with the next sign, it is a symbol of the sleeping eye of God: "The Spirit of God moved upon the face of the waters."

The passive female element; what has been there from the beginning of all things. "And God divided the waters which were under the firmament from the waters which were above the firmament."

2

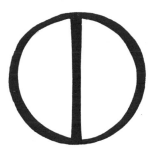

The active male element; what comes from on high; the effective element in time." And God divided the light from the darkness."

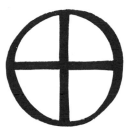

As the male element pervades the female, so creation takes place, since everything belonging to the living world is compounded of the confluence of male and female. In remote ages in the East, and also in early Northern mythology, this sign of the wheel-cross was a symbol of the Sun.

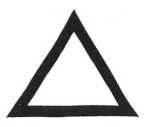

The triangle is an ancient Egyptian emblem of the Godhead, and also a Pythagorean symbol for wisdom. In Christianity it is looked upon as the sign of the triple personality of God. Again, in distinction from the next sign, it is another sign for the female element, which is firmly based upon terrestrial matters, and yet yearns after higher things. The female is always earthly in its conception.

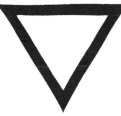

The triangle standing upon its apex is, on the other hand, the male element, which is by nature celestial, and strives after truth.

3

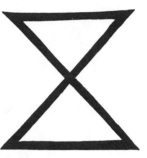

Both figures now start moving towards one another, and as they touch each other with their apexes they form another figure, entirely new in appearance, without, however, either of the original figures being damaged or interfered with in any way.

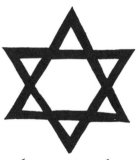

When, however, they pass through one another, the nature of both is fundamentally altered and, as it appears, is practically obliterated. A complicated and entirely symmetrical pattern is formed, with new and

4

surprising sections and correlations, in which six small distinct triangles are grouped around a large central hexagon. A beautiful star has appeared, though, when we examine it, we see that both the original triangles still retain their individuality. Thus it is when a perfect marriage binds man and woman together.

We now carry the movement of the triangles a step further, so that they part again and form a square standing upon one of its corners. The triangles have a common base line, but they point away from each other instead of towards each other as before. This figure is the simple sum of the two triangles lying next to, but quite clear of, each other. This sign also stands for the four Evangelists.

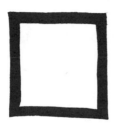

The square is the emblem of the world and of nature. As distinct from the triangle it is the Christian emblem of worldliness. In it is symbolized the number four; this has a host of significations, as: the four elements, the four corners of the Heavens, the four Evangelists, the four rivers of Paradise.

The furca, or fork, a mediaeval symbol for the Trinity, is also a Pythagorean emblem of the course of life, in the form of a rising path with fork roads to Good and Evil. This sign is very ancient in origin, and is probably connected with the next sign:

Three triangles all touching at a central point to form a new figure. This is an old symbol for the Godhead. Beyond this nothing is known about it.

This is an old emblem for the sun, with three rays. The cross strokes at the ends of the rays symbolize the vault of the Heavens.

5

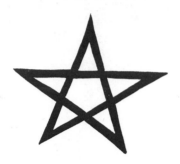

The pentagram, a five-pointed star drawn with one stroke of the pen: this sign belongs, as do many others depicted here, to the most primitive of mankind, and is certainly much older than written characters. Signs of this kind are quite the most ancient human documents we possess. The pentagram has had several different significations at different times in the history of man. The Pythagoreans called it the pentalpha, and the Celtic priests the witch's foot. It is also Solomon's seal, known in the Middle Ages as the goblin's cross. It also represents the five senses; the male and female principles are also conveyed by the arrangement of the five points. Amongst the druids it was the sign of God=

6

head, and to the Jews it signified the five Mosaic books. This sign was also popularly believed to be a protection against demons, and, by analogy, a symbol of safety. It is believed too to be the emblem of happy home-coming, whence its employ=ment as an amulet. In ancient times it was a magic charm amongst the people of Babylon.

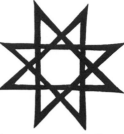

The octogram, an eight-pointed star drawn with one stroke of the pen. No explanation of this sign is known.

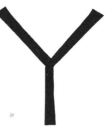

The fork. This sign, with which

we have already dealt, has a further meaning, namely, the expectant soul, man gazing aloft with outstretched arms.

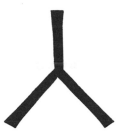

The same sign, inverted, in contrast with the previous sign, expresses salvation descending from above and spreading over the world below.

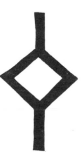

The two signs approach one another and form a new figure. As they come into contact they enclose a space between them.

They proceed to intersect, the prongs of the forks appearing once more in the figure.

The intersection is complete, and results in another six-pointed star. The two original figures, which were so definite in their impulse towards union, are completely absorbed by the new figure, which radiates strength on all sides from a central point, and which, though itself motionless, generates motion all around it.

7

As the last five signs expressed the fate of the soul, so the next five symbolize the nature of the human intellect:

Creative intellect

Passive intellect

Disordered intellect

Active intellect

The intellect in action

The three lines, whether they run vertically or horizontally, or whether they move together or independently, achieve nothing, emerging from the void and returning to the void whence they came. Only the creative intellect encloses a space and forms a definite figure, the three bodyless lines becoming a real object of which the triangle is the symbol. When the intellect is shattered, the figure dissolves once more and the lines return to the void, cutting through each other in general disruption.

8

The next is a series of signs illustrating the vicissitudes of family life:

Man

The woman becomes pregnant,

Woman

and bears a child.

Man and woman united for procreation.

The family; man with his wife and children.

9

Apart from family life there is friendship between men.

The widow and her children.

Men quarrel and fight.

One child dies.

The man dies.

The forlorn mother with her remaining child.

The mother dies, leaving

The unborn child.

one surviving child, bearing within himself the germ of a new family.

The true essence of the sexes and their relationships, and the main private incidents of family life, are shown in the most inspired form in these signs, and it would be impossible to disclose the simple story of the life of mankind more lucidly in any words.

The next series of signs illustrates the waxing and waning of human life.

From the moment of birth the inner life begins to develop; the circle is the body enfolding it.

The trinity of body, mind and soul is now fully manifested. The immortal essence, the soul, is the point in the centre. The

11

inner circle represents the intellectual life, the mentality of man, whilst the outer circle represents corporeal man.

The intellect becomes disordered and turns its strength against itself and the body.

It breaks right through the confines of its mortal frame and the man dies, whereupon the soul becomes homeless and returns to the place from whence it first came.

The sign of simple activity. The efforts of mankind fill the space assigned to them, traversing it throughout.

The multiform activities of mankind are shown by repeating the preceding figure several times over, in different compartments.

Orderliness. The square is it-

self a sign of order, and fits perfectly into a similar figure, and that is also the fundamental principle of every thing with which we surround ourselves.

This is destruction, or disorder, in which all concord disappears, and confusion takes the place of harmony.

The triceps, an old Nordic sign. A symbol of heavenly power. By tracing its perimeter from the apex back to the apex we realize the meaning of the words: "The Will of God, descending upon the world, sways to and fro over the Earth and returns again on High."

# 2. The Cross.

The Latin Cross, Crux ordinaria, in early times called God's mark. The most exalted emblem of the Christian faith, the Sign of all Signs. By far the greater number of signs in the Western world are based on the shape, or part of the shape of the Cross, whether they be imperial monograms, masonic signs, family signs, chemical symbols, or trademarks.

St. Peter's Cross. According
14

to legend, St. Peter died on an inverted Cross.

St. Andrew's Cross, upon which St. Andrew suffered a martyr's death. Also called the Crux decussata. The boundary Cross of the Romans, derived from the Cross used by them as a barrier.

St. Anthony's, or Egyptian Cross; Crux commissa. Also called the Tau Cross, from the Greek letter "T", tau. St. Francis used this as his signature.

The Greek Cross, Crux im=
missa quadrata. From this and
the Latin Cross the following
forms were derived in the middle
ages for heraldic purposes:

Cross botonnée or treflée

Cross patée

Cross fleury or Cross of Cleves

Maltese Cross

Cross pomée or pommelly

15

Cross patée fitchée

The papal Cross, or the triple Cross of the Western peoples.

A common figure appears in this connection as the fork or furka Cross, also called the thieves' Cross.

The broken, or chevron Cross

The patriarchal Cross, or Cross of Lorraine.

The Cross potent

16

Another form of the Cross potent. Allied to this is the Cross moline, which is met with in two forms:

The eight-ended Cross of the Russian Orthodox Church. The lower cross-bar represents a footrest.

The Russian Cross with a slanting footrest.

The Cross crosslet, also called

17

the Holy Cross or the German Cross. Amongst the Gnostics, the sign of the fourfold mysteries.

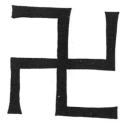

The Crusaders', or Jerusalem Cross.

The Svastika, or Fylfot Cross. Derived from the Sun wheel:

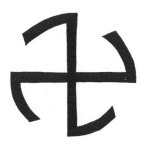

by breaking the circumference of the circle:

Amongst Early Christians, this, as well as many other of the symbols that follow, was used as a disguised Cross during the persecution of the Christians. Hence its name Crux dissimulata. It was also called Crux gammata, from the fact of its being made up of four Greek gammas.

An elaborated form of the Svastika.

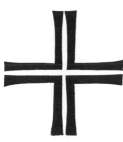

The Cross voided, or gammadia, so called from being composed of four gammas. Closely related to this is the beautiful badge of the German gymnastic clubs:

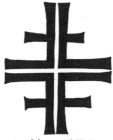

composed of four "F"s, standing for: "Frisch, fromm, fröhlich, frei." (Hardy, godfearing, cheerful and free.)

This Cross, either hewn in the stone or painted on the walls of Roman Catholic Churches, denotes that they have been consecrated. This is also met with sometimes in the form of a detached Cross within a circle:

Roman Sacred Cross

The Egyptian symbol of life, the ansated, or looped Tau Cross, Also called the Key of the Nile.

19

A Christian ansated Cross, derived from the Egyptian sign.

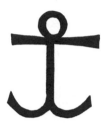

The anchor Cross was, like the last one, a disguised Cross. In it we see the Tau Cross conceal= ed beneath the common symbol of the Anchor.

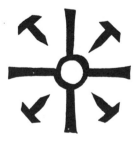

Coptic Cross, with the four nails.

The raised Cross occupied a large place in the early Christi= an representations of the Cross:

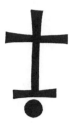

The Earth, upon which the Cross was erected, is here represented by a dot. Sometimes there were six dots, representing grains of sand:

From an old coin.

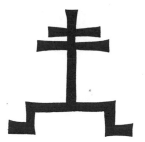

The Cross erected on three steps.

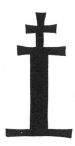

The Cross erected on a column

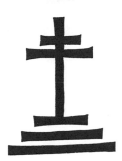

Two raised Crosses which were also designed as Archangelical Crosses.

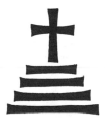

A Cross standing upon four lines. Why there should be four is difficult to explain. They may symbolize the four Evangelists.

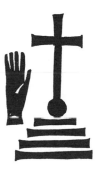

A raised Cross with a hand beside it; from an old coin.

21

# 3. The Monogram of Christ or Chrismon

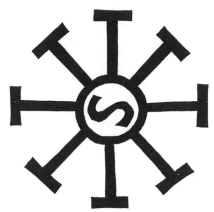

The Gnostic Sun monogram. The cross-strokes at the ends of the rays represent the vault of the Heavens.

The double Cross is also a very early Christian symbol. It consists of the Greek "X" and the Cross.

Chrismon composed of an "I" and a Greek "X".

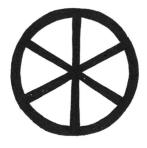

A very ancient pagan Sun wheel, interpreted by the Christians as a Chrismon. "I"=Jesus, "X"=Christ.

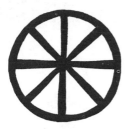

The double Cross in a circle. See above.

The foregoing sign with a second circle. The outer may be interpreted as the Finite, the inner as a sign of Eternity.

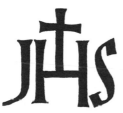

The Monogram of Jesus. Instead of the first three Greek letters of the word Jesus, IHC. Later the H was regarded as a Latin letter, and the meaning attributed to the monogram

became: "In hoc signo", i. e. "In this sign."
It also denotes: "Jesus Hominum Salvator", i. e.: "Jesus Redeemer of Mankind". A very common interpretation in Germany today is: "Jesus Heil und Seligmacher". (Jesus, Saviour and Redeemer.)

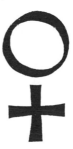

The most widespread and best-known Chrismon. It was probably originally developed from an ancient oriental representation of the rising sun, in which, in a way which seems odd to us, the ball of the sun is shown over a Cross representing its rays:

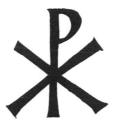

23

From this, at a later date, came the sign:

Closely related to this stands the ansated Cross:

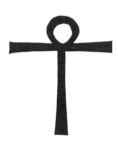

The so-called Mirror of Venus, the symbol of the planet Venus:

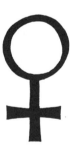

is also related to an old orien-

tal symbol for the Sun, formed thus:

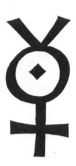

According to legend the Chrismon:

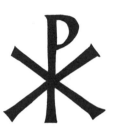

appeared in a dream to the Emperor Constantine accompanied by a voice saying: "In this sign shalt thou conquer." He accordingly had the sign emblazoned on his war banner. This banner is called the Labarum.
The sign is composed of the two

Greek initial letters of the name Christ: "X" and "P". It is also called the Signum Dei, and is, possibly, as a Christian symbol, older than the Cross itself.

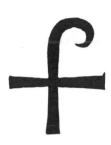

A form of Chrismon frequently encountered, in which the "P" is simplified into a hook. Here we have a Cross in place of the "X".

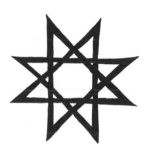

A sign with which we have already met as the octogram, which is here to be considered as the

intersection of four "X"s. It represents a concealed Chrismon.

Two signs widely used in the Christian Church from very early times, namely, Alpha and Omega, after the passage in the Apocalypse: "J am the Alpha and the Omega". The letters often appear with the Cross proceeding from them. In the next example the form of the Omega has altered:

25

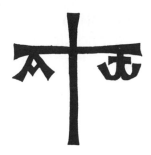

Here the Greek "P" is replaced by the Latin "R".

The two letters are used in connection with the Cross in many different ways, of which the above sign is a good example. It is also frequently met with in conjunction with the Chrismon.

The Tau Cross with the Alpha and Omega. This, like all the other monograms illustrated here, is definitely connected with Christ.

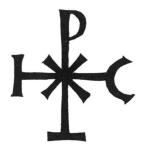

A combination of the Chrismon with "I" and "C", Jesus Soter, Jesus Christ, Saviour.

In this example the Latin "H" is added, which may well stand for HOC.

26

The line above the monogram represents the Holy Ghost in this example also.

A beautiful Chrismon reminiscent of the Egyptian ansated Cross. The variety of these monograms is very great, and the inventiveness shown by the Early Christians in their design is boundless.

Here "Y" takes the place of "I". This was not unusual in the Middle Ages.

Monogram of Jesus, beneath an old sign denoting Redemption, or the Holy Ghost.

This, like the next sign, is a fur-

27

ther development of the Chris=
mon.

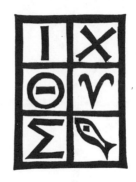

The fish sign is a symbol used
from the very earliest days of
Christendom. The letters form=
ing the word "fish" in Greek,
(Ichthys), are the initial letters
of five Greek words meaning:
"Jesus Christ, Son of God,
Saviour."

It is sometimes questioned
whether the rosette in this figure
has any particular significance.
One theory is that the Omega
beneath the rose should be read
as an "S" and that the sign
means Rosa Rosarum, one of
the names by which the Virgin
Mary is known. In that case
the meaning of the rose itself
also becomes clear.

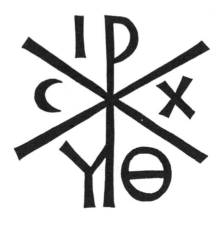

The Chrismon in conjunction
with the Greek word for fish.

The following sign appears as an impression on Greek Communion wafers, and means: "Jesus Christ, conquer!"

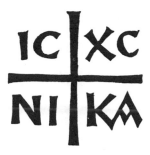

The following sign is taken from a mosaic in the Catacombs. The Chrismon in three different sizes, superimposed upon one another.

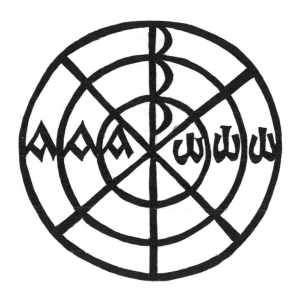

# 4. Other Christian signs.

These are six symbols for the Holy Trinity.

In some of them the Chrismon combines with the triangle, the sign of God the Father. In the last sign, the three circles represent the three Unities, each of which is self=contained and complete in itself. A detailed analysis of each sign is hardly possible.

The next sign is a simple symbol of the Trinity, and presents no difficulty to the modern mind.

Amate! Love!

In this figure the three Persons of the Trinity are represented in the simplest signs that can be used.

Mother of God.

In Greek: Meter Theou, here shortened to Mer Thu.

The strokes above this monogram denote holiness, as in the conventional symbol of the halo.

A cruciform monogram composed of the Greek words for light (Phos) and life (Zoe).

The monogram of Mary.

31

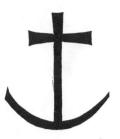

A charming explanation of this Cross, sometimes called the anchor Cross, is as follows: Christ, symbolized by the Cross, born of Mary, symbolized by the crescent Moon.

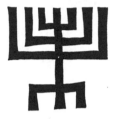

The seven-branched candlestick, the symbol of the Old Testament.

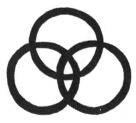

This is another early sign for the Trinity.

Each circle has its own centre and is therefore complete in itself; at the same time it has a large section in common with each of the other circles, though only the small central shield is covered by all three circles. In this shield they possess a new central point, the real heart of the whole figure.

The symbol of Faith, the patient expectation of salvation coming from above.

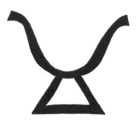

The symbol of the Universe. The dark centre is the Orb of

Earth and Water, the old conception of the World, surrounded by the inner ring of the aerial ocean, and the outer ring of the empyrean.

This is a simplified representation of the Orb of the World. The old conception of the Earth was that it is divided thus. The centre of the World was Jerusalem, the place where salvation came to mankind. The upper half of the Orb is Asia. The vertical line represents the Mediterranean Sea, on the right and left of which lie Africa and Europe respectively. In Early Christian Art the Lord was shown carrying this Orb in his hand; in later times this was altered to a ball with a Cross upon it.

Two signs used to exorcise evil spirits. In the case of both these signs, as with the pentagram and the octogram, it is worthy of note that they call for a certain dexterity, and that a clumsy person would be unable to draw them.

33

Another sign, also representing the World, which possibly belongs to the same category. It is based upon the square, and admits of many interpretations.

# 5. The Monogram.

The Monogram is a sign composed of written characters interlaced with one another. The Latin uncials, from which our present day writing is derived, are signs of the utmost dignity and simplicity.

ANTS

We are, generally speaking, so accustomed to connect the idea of sounds with the sight of these forms, that it is only with difficulty that we can dissociate the letters from this, and think of them as symbols.

4 5 7

The same is true of Arabic numerals, which, indeed, owe their origin to quite another part of the World, but with whose character as signs we are, however, not less familiar.

The Monogram plays an important part in the World of signs. The Greeks were the original inventors of the monogram, which reached the height of its glory in the Byzantine period. It is sometimes difficult to interpret monograms, as their letters are often very much disguised, or turned back to front, or only partially drawn, so that it frequently requires great skill to discover the names concealed in them.

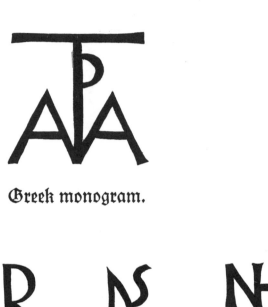

Greek monogram.

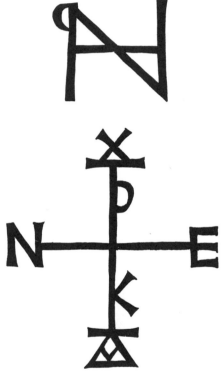

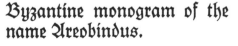

Byzantine monogram of the name Areobindus.

Byzantine monograms whose meaning is unknown.

36

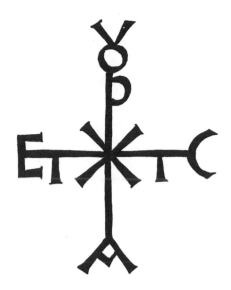

Another monogram showing a religious influence; this is very similar to a Chrismon illustrated further back.

In many Byzantine monograms we find the genitive form OV. The documents of that period concluded with names in the genitive case, and the monogram then constituted the end of the document.

A monogram formed with the Christian Tau Cross.

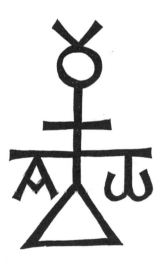

This monogram also shows the influence of the Christian religion.

37

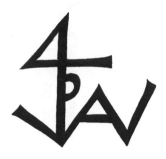

The monogram of a man with
the Christian name Paul.

Arkadius

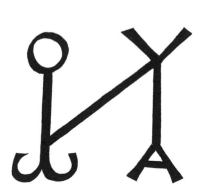

The monogram of the name
Johannes.

Nikolaus

38

Vivas in Deo. God be with you.
An expression of good-will
found in early Christian letters.

The monogram of Bishop
Arethras of Caesarea.

Bene Valete. Good Health. A
form of greeting often found at
the conclusion of old papal do=
cuments.

Monogram of Theodosius II.
Byzantine period.

Palaeologus

The name sign of the Emperor Justinian.

Monogram of Ulphilas, Bishop of the Goths.

Manuel II.

## Pipin the Short

The Cross was drawn by a scribe, and the dots added by the King.

## Charlemagne

The only part drawn by the Emperor himself was the lozenge in the middle, for he was illiterate. A scribe then added the remainder.

Two signs of Otho the Great, of which the first has no connection with his name.

41

Byzantine monograms are the most beautiful examples we have of designs composed of letters, and in their construction they all bear evidence of great skill and serious thought. This chapter ends with a beautiful Byzantine imperial monogram, the interpretation of which is, however, unknown.

# 6. Stonemasons' signs.

These were signs by which journeyman stonemasons in the Middle Ages distinguished their finished work. They are to be found carved on many German cathedrals and other mediaeval buildings.

The Masonic lodges were powerful guilds of stonemasons, the chief one being the Masonic lodge of Strassburg, which had authority over all the other lodges of all the German-speaking countries. The members of these guilds were strongly bound together in their work. Originally these Masonic lodges were entirely controlled by the Church, but they soon shook themselves free from the influence of religion. For a long time, however, they still remained powerful societies of men remarkable for their principles and adherence to the Church. On the completion of his apprenticeship the journeyman received a sign, conferred upon him by his master. This sign was taken from a so-called Mother-figure, which differed in each Masonic lodge. These different Mother-figures were based upon triangulation and squaring, the trefoil and the quatrefoil. From these signs we can tell exactly whence the wandering journeymen came who worked on any particular building.

Disgraceful conduct might lead to a mason being deprived of his sign, and excluded from his lodge. The first duty of a journeyman when he came under a new master, in the course of his travels, was to construct the sign of his own Mother lodge, before his assembled colleagues in the lodge room, and then to explain it symbolically. Master masons were allowed to enclose their own signs within a shield.

43

Here follow a few stonemasons' signs of different periods:

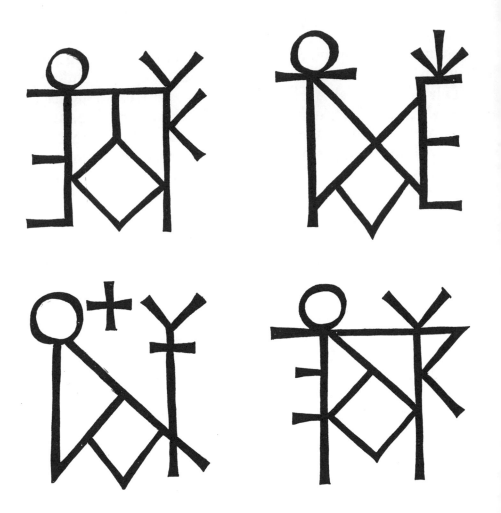

The above are four Byzantine masonic signs, actually purely alphabetical monograms, closely related to the designs in the last chapter.

Six Roman signs, remarkable for their beautiful clearness and simplicity of form. To the modern mind these signs are typical of the vigorous age which produced them.

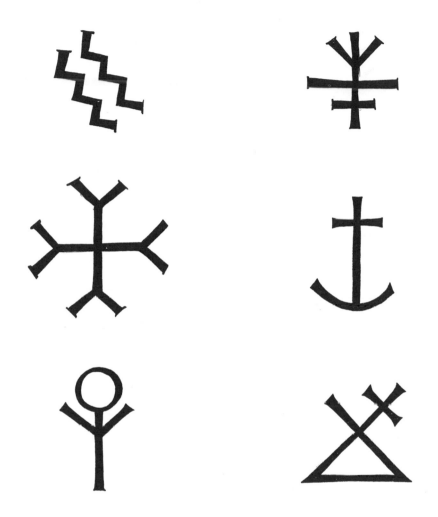

By far the commonest masonic signs are those on the Gothic

buildings that still survive. They are often to be found in great profusion, and show considerable ingenuity. The two following pages show examples of these:

47

This chapter concludes with a sign composed of eight subsidiary signs, taken from a French calendar. It probably represents the eight corners of the Heavens, the whole forming a rhumb-card.

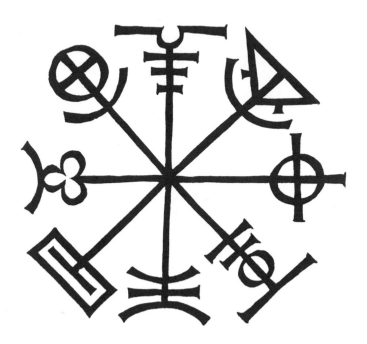

# 7. The four Elements.

Fire.
Dry warmth
Fiery, choleric

Air.
Damp warmth
Airy, sanguine

Water.
Damp cold
Fluid, phlegmatic

Earth.
Dry cold
Solid, melancholic

The four elements play an important part in all the mysticism of the Middle Ages. It is from this that the above interpretations are taken.

49

The four elements are also symbolized in a circle as follows:

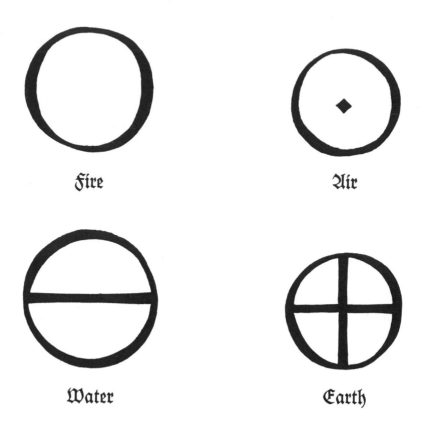

Fire                                          Air

Water                                        Earth

Although of the signs on the previous page only the two first are clear, namely, fire blazing into the heights and water sinking into the earth, the interpretation of these circle signs seems more natural to the modern mind.

# 8. Astronomical signs.

The symbol of the Sun.          The symbol of the Moon.

The symbols of the planets are amongst those most frequently employed. They play an important part in Astrology, to which, indeed, they owe their origin. They are, for the most part, composed of Crosses, the symbols of the elements, and the symbols of the Sun and Moon, which denote activeness and passiveness respectively.

  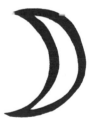

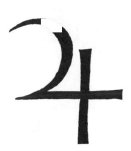

The nature of Jupiter is lunar, and it dominates the elements. This symbol also stands for tin.

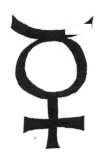

Mercury.

The nature of this planet is both solar and lunar, and it dominates the elements. The sign is hermaphroditic. It is also used to represent quicksilver.

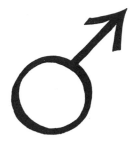

Mars.

This sign originated in the Zodiac sign for Aries, which is shown pointing in the opposite direction, towards the Sun. This was later altered to an arrow, apparently pointing away from the Sun. Also the sign for iron.

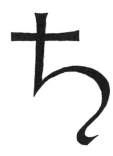

Saturn.

Lunar nature, dominated by the elements. Lead is represented by the same sign.

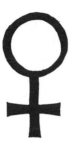

### Venus

is solar, dominating the elements. Also the sign for copper.

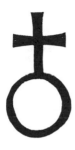

### The Earth

is solar, and is dominated by the elements.

The remaining planet symbols are largely of later origin, and spring from different associations of ideas:

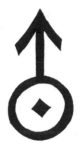

### Uranus

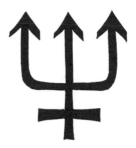

### Neptune

### Vesta

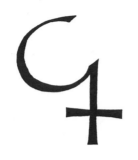

Ceres

The sign for Vesta represents an altar with a sacrificial fire upon it. Neptune is represented by a trident.

The signs of the Zodiac are identified with the constellations, and date, as do the planet signs, from very remote times. They are common to all nations.

Pallas

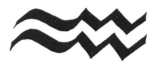

Aquarius, the water-bearer. January.

Juno

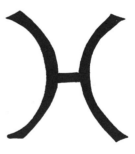

Pisces, the fishes. February.

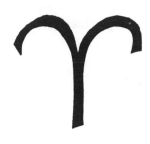

Aries, the ram. March.

Cancer, the crab. June.

Taurus, the bull. April.

Leo, the lion. July.

Gemini, the twins. May.

Virgo, the virgin. August.

Libra, the scales. September.

Capricornus, the goat.
December.

Scorpio, the scorpion. October.

Sagittarius, the archer.
November.

As the Sun traces its path through the firmament of the fixed stars, it crosses these constellations, and each month is named after the constellation in which it occurs. The exact position of the constellations is gradually altering in relation to the calendar year, so that at the present time the beginning of the month no longer coincides with the entry of the sun into a new constellation. About the first two=thirds of the month belong to the previous constellation, and only in the last third does the conception still hold true.

Aquarius is represented by waves, Aries by horns, Taurus by a bull's head, Gemini by two

parallel strokes; the sign for Cancer was, originally, two crabs facing to one another. In the signs for Leo and Capricornus the outlines are vaguely reminiscent of the animals themselves; the sign for Virgo is a monogram of the Virgin Mary. Libra is represented by the beam of a pair of scales, Scorpio can be recognized by his sting and Sagittarius by his arrow.

## The Seasons of the Year.

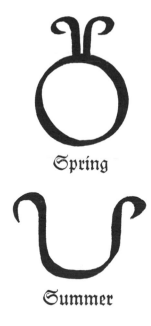

Spring

Summer

Autumn

Winter

The symbolism of these signs is not difficult to grasp, illustrating, as they do, the waxing and waning of life and, in the case of Winter, protection in a house from cold and snow.

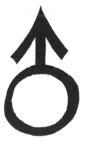

Morning; the rising Sun.

57

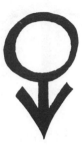

Evening; the setting Sun.

Day and Night, Light and Darkness, Openness and Concealment.

58

The Romans named the days of the week after the planets, as follows:

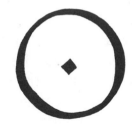

Sunday, dies solis

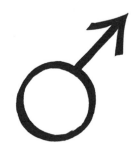

Monday, dies lunae

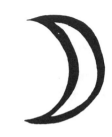

Tuesday, dies martis

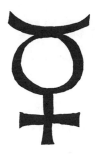

**Wednesday,** dies mercurii

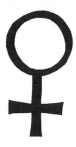

**Friday,** dies veneris

**Thursday,** dies jovis

**Saturday,** dies saturni

# 9. Astrological Signs.

These are used for casting clearly defined horoscopes, in which the planets and the signs of the Zodiac find themselves in direct relation. The casting of the horoscope depends, amongst many other considerations, upon the way in which they stand in relation to each other. The planets stand to one another:

In conjunction, that is at a distance of 0 degrees.

Semi-quadrate, or 45 degrees

Semi-sextile, or 20 degrees

Sextile, or 60 degrees

60

Quadrate, or 90 degrees

Quincunx, or 150 degrees

Trigon, or 120 degrees

Opposition, or 180 degrees

One and a half quadrates, or 135 degrees

Constellation in a state of retrogradation

61

The Moon in ascending node  The Moon in descending node

It is impracticable, in the present connexion, to go any deeper into Astrology and the casting of horoscopes. Our only concern is with the signs themselves, which, as in other cases we have mentioned, contributed so materially to the preservation of the mystery of this occult science. They did, however, possess a practical advantage in providing a shortened method of expressing certain ideas. How very important such shortening was can be seen in mathematics. For the most ordinary calculation we employ signs which we do not illustrate here simply because they are already known to everyone, but which must be mentioned in the same chapter as the above signs, with which they are closely connected.

# 10. Botanical Signs.

Tree

Annual

Bush

Biennial

Perennial plant

Another symbol for biennial

Male bloom

Pernicious, suspect

Female bloom

Poisonous

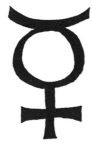

Dioecious bloom

Very poisonous, deadly

64

# 11. Chemical Signs.

The following signs are taken from the old chemical system. Three philosophical signs for:

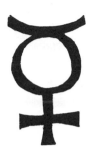

Mercury
The metals

Sulphur
The combustible elements

Related to these signs are those of the seven metalloids:

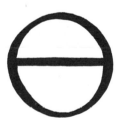

Salt
The metalloids

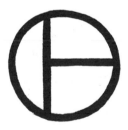

Vitriol

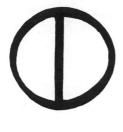

Saltpetre

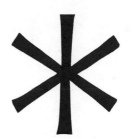

Sal Ammoniac

Alum

Sulphur

Salt

Antimony

Amongst the great variety of signs that were used in early chemistry, there are many which are remarkably beautiful.
Even if the meaning of many of the signs is almost forgotten, nevertheless there is a depth of feeling in their design, and in them we see with what a wealth of emotional ideas our ancestors connected these things.

Amalgam

Alum

Antimony

Another sign for Alum

Potash

67

Arsenic

Lead

Another sign for arsenic

White lead

Olive oil

Another sign for white lead

Anglesite

Borax

Hematite

Alcohol, or spirits of wine

Bolus

Iron

Copiapite

Glass

Essential oil

Talc

Vinegar

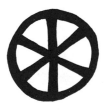

Subacetate of copper

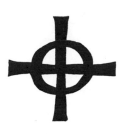

Subacetate of copper crystals

Another sign for Metal lime

Urine

Lime

Metal lime

Copper saffron

71

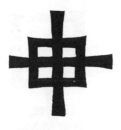

Iron vitriol

Lye

Azurite, lapis lazuli

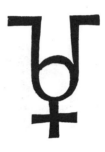

Minium

Alkali

Orpiment

Precipitate

Steel

Aquafortis

Sublimate

Brimstone

White arsenic

73

Wax

Tartar

Water

Tin

Vitriol

Wood

Sublimation

Precipitation

Annealing

# 12. House- and Holdings-Marks

House-marks were, at first, private signs of peasant proprietors, and their use was originally confined to their holdings, all moveable property upon which was distinguished by the holdings-mark.

The holdings-mark was displayed:
By being punched into floated timber, which could thus be sorted out at the end of its run.
By being snipped into the ears of domestic animals and the feet of web-footed animals.
By being clipped out of the coats of horses.
By being painted on sacks, and on the fleeces of sheep.
By being cut into the upper bills of swans.
By being ploughed into the surface of the fields.
By being carved on trees and on sticks used for drawing lots.
By being embroidered on rugs and cloths.

By being punched or branded into the iron or wooden parts of agricultural implements, respectively, and by being branded into the hides of domestic animals and the horns of cattle.

At a later date these house-marks came to be used as personal signs, and often underwent modifications at the hands of different members of the family. Later still they were used as trade-marks and the marks of craftsmen and artists. The suggestion that they owe their origin to the Runes is only to be accepted in rare cases.

The simplest form of house-mark is the one composed of notches, and in most of these straight lines predominate.
Curves were brought into use much later, and presuppose a different method from that of snipping and carving, more in the nature of painting or writing.

76

The above is a design on a stick used for drawing lots.

The peasant communities of earlier times drew lots amongst themselves, to decide who should be their representative to look after the interests of their hold=ings; this they did by means of lottery sticks of the different holdings, which were cast into a hat and drawn. These sticks were made of wood, and bore the house=marks on them; they were often newly made for each occasion, being cut from willow twigs, all of the same length, from which the bark was carv=ed in such a way as to show the white wood beneath it.

The following are a few simple forms of private signs:

77

clature. This nomenclature is of considerably later origin than the signs themselves, and arose from close associations of ideas. It is not quite certain whether a particular sign, for instance, was meant to represent a frying-pan, or whether a circle with a vertical line attached to it was described as a frying-pan when it became necessary to refer to it in words.

Even to this day craftsmen mark their own tools in this manner. The badges of rank on uniforms come into the same category. There are numerous forms which are constantly recurring as the basis of house- and holdings-marks; these have been given a special nomen-

These two forms were described as forks.

The barrel ladder

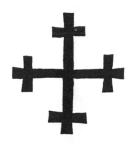

The windlass

The strut

Another windlass

Another strut

The straight edge

The chevron

The windmill

The spade

Another windmill

The ear of oats

The chair

The house

The ladder or stretcher

The gooseneck

The key

The manure heap

The frying pan

81

The sword

The double flail, or double hook

The arrow

The horse=shoe

The mill=wheel

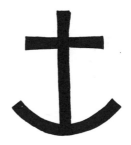

The anchor

82

Another anchor

The Crow's foot, or witch's foot

The carpenter's square

The pot=hanger

The wolf's tooth, or hanger

The hour=glass

The half hour=glass

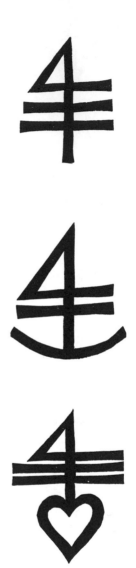

4

The sign of Hermes

This sign is met with quite as
frequently reversed, as is the
case with a great many other
signs, but this does not in any
way alter their meaning.

The way in which these signs
were modified can best be illu=
strated by this particular sign,
which forms the basis of many
trade=marks and craftsmen's
signs.

84

The next series illustrates the way in which the various members of the same family adopted the original mark of their house and modified it for their own use:

The signs are those of four brothers, and are based on the Cross.

The signs of a man, his brother, and his son. The ground upon which these signs are constructed is a mushroom.

The following family signs are based on the square:

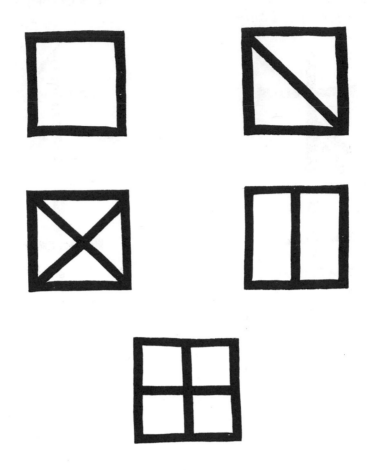

That the members of the same family should desire to distinguish the work of that family by a particular sign is quite natural, as is also the wish of each member of the family to distinguish his own individual work. In the next series this idea is still further illustrated and explained.

The manner in which the same sign is employed by successive genera-
tions of the same family is shown in the following genealogical table:

1. The founder of the family. 2. The eldest son.
3. The eldest grandson. 4. The second grandson.
5. The son of the eldest grandson. 6, 7 and 8. The
three sons of the second grandson, in seniority
from left to right.

The first sign remains unchanged in the line of
primogeniture. The younger sons add various
strokes to the original sign. This sign is again
modified by their descendants, except in the case
of the eldest son, who always takes over his
father's sign unaltered.

We will now trace the signs of the second line.

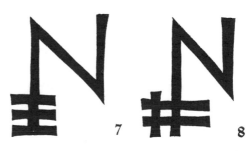

In the second line a similar process of modification takes place, quite independently of any other line. In the other collateral lines, and in the fourth or fifth generation, of course, the accumulation of added marks begins to become confusing; so that the process cannot be carried out over many generations.

The second son, from whom the second line descends.

The grandsons in the second line.

The head of the family is childless.

The two sons of the second grandson of the second line.

In the case of all these signs, the actual original base sign has been altered by additions. The principle of modification by addition is also applied in other connexions. By this means it is possible

88

to indicate differences in a most subtle way, without destroying uniformity. When these little added strokes were separated from the original sign, they were called countermarks. A very charming example of this is illustrated here; the signs are old marks denoting different degrees of excellence and fineness of the same goods, on the same principle that at the present day articles are described as being of the first, second or third quality.

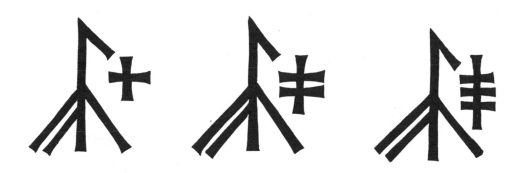

Countermarks also played an important part in old trade=marks, and are of various kinds; crosses, dots, rings, and so on. They belong, for the most part, to a later period.

89

Some of the old house=marks were famous because of the persons or families that originated them.

Michelangelo

Welser

Hans Burkmair

Peter Vischer

Fugger

Hans Sachs

A few further house-marks, principally remarkable for the ingenuity of their designs:

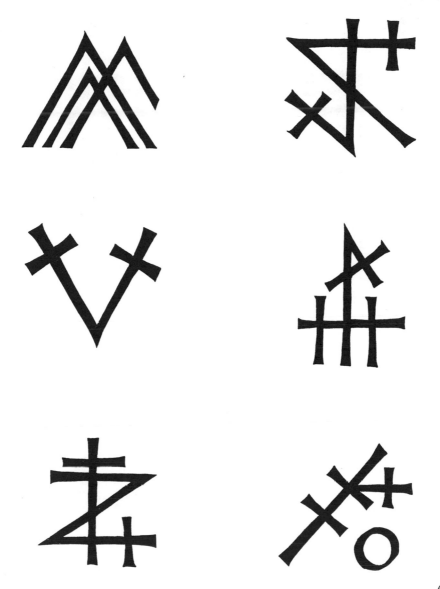

From these marks, in later times, were derived the first printers' devices, most of which contained their names in one form or another.

# 13. Signs from various sources

The sign of Trinacria, or the triskelion. This is probably derived from three triangles, from each of which one side has been removed, standing on their apexes. The figure gives one the impression that it is moving forward along an imaginary ground line by revolving around its central point: whence it developed, at a later date, into the representation of a creature consisting of nothing but three legs running rapidly around one another.

The triquetrum frequently re=

places the previous sign; it con= veys the same idea of movement in the form of a rolling wheel.

This talisman has its origin in the Gnostic conception of the World. It represents the four elements. Nothing further is known of it.

The waxing and waning Moon, between which runs the course of life. This sign is symbolic of the vast and determinant in=

fluence of the Moon upon the life of man.

An oriental symbol of the soul's pilgrimage through life: the soul climbs up through the four belts of the world, or elements, to its purification, and wins through from darkness into light.

Saracen talisman

When two triangles are joined in this way, the upper half of the sign becomes the water triangle of kindness, gentleness, and nobility, whilst the lower half is the triangle of fire, of the fiery rage of God.

The signs that follow come down to us from the early Germanic peoples, and nothing further is known of them:

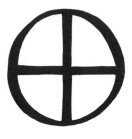

The Sun-Cross or Cross of Wotan.

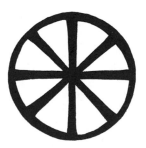

The eight-spoked wheel

94

The dragon's eye

A few signs are appended which are nothing more than highly simplified pictures, and as such do not require any further explanation.

The eye of fire

The wave

Running water

The sign of the Vehmic Courts, or the eight=angled figure.

The old sign for the lily, as it is frequently found on armorial bearings; its upper part is form= ed from the fleur=de=lys.

It was not until later that dis=
tinctions began to be drawn be=
tween different kinds of crowns.

The lily of Cleves, the upper
half of the fleur=de=lys. This
figure is also found on armorial
bearings.

In old calendars, three crowns
represented the three Magi.

The shepherd's and Bishop's
symbol, the crozier.

The symbol of royalty, the
crown.

96

Three arrows bound together;
the sign of unity.

The city

The destruction of the city

Examples have already been given of destruction being indicated by inverting the figure.

The simplified outline of a jug.

In its simplest form the star has many shapes.

The three=pointed star is sel=dom encountered, and, indeed, hardly seems to us to be a star at all.

The four=pointed star is cruci=form, and is a phenomenon carrying a grave and solemn warning.

The five=pointed star abounds

97

in different interpretations. The impression it leaves is a cheerful and happy one.

The six-pointed star bears the same urgent message as the four-pointed star, though it is richer and fuller in form. This is the true star, and satisfies most nearly the general conception of a star.

In the seven-pointed star are repeated the attributes of the five-pointed star, and in the eight-pointed star those of the four and six-pointed stars.

# 14. Runes

As early as the second century the Goths learnt to recognize Greek culture, and designed a series of signs derived from Greek and Latin cursive script. These signs we call Runes. Following the example of the Greeks they gave to each sign a sonorous name. The shapes of the letters conformed to their mode of writing and the uses to which they put it. Most of their inscriptions were either scratched or carved; Runes are therefore almost entirely rectilinear in form, vertical lines predominating.

In the fourth century the knowledge of Runes was spread to Germany and other Teutonic countries. In Scandinavia Runes were still partly in use in the seventeenth and eighteenth centuries.

Rune magic was peculiar to North Germany, and we have only very fragmentary information about it. There the Rune represented the object after which it was named; the Runic character became the object itself, and with it good and evil could be worked. The magic properties of each Rune were only known to very few.

Thus ↑ should bring victory, ✕ protected one against the poisoned cup, ᚹ induced madness. Runes scratched on a drinking vessel brought oblivion to whomever drank from it. A cup filled with poisoned drink upset itself if the Runes scratched upon it were benign. A good example of Runic magician was the Scandinavian bard Egill. He divined Runes beneath the couch of a sick damsel as being the origin of her illness; he dug them up and carved benificent Runes in their place.

As late as the fourteenth century Episcopal ordinances were

disseminated against Rune magic.

For purposes of soothsaying, Runes were only used indirectly: it was believed that the dead could be awakened by means of Rune magic, and that they could foretell the future.

Thurs : Giant

Feu : Cattle

Ansur : Asa, God

Ur : Bison

Rad : Cartwheel

100

Ken : Torch

Hagall : Hail

Geofu : Gift

Nied : Necessity, thraldom

Wynn : Comfort

Is : Ice

Jara : Year

Jlhs : Elk

Peorth

Sygil : Sun

Yr : Yew, Death

Tir : Honour, the god Tyr

102

Biarkan : Birch

Lagu : Water, Sea

Eoh : Horse

Ing : the god Ing

Man : Mankind, Man

Dag : Day

103

Ogal : Possession

The Runes were frequently used turned back to front, and their angles were occasionally rounded into curves.

Great endeavours have recently been made to show that Runes were much more extensively used by the old Germans, and they have been given a more prominent place in the history of that nation than they appear to deserve.

In many of the signs illustrated in this book the Nordic influence can be clearly traced; but the basic forms, with their wealth of significance and symbolism, undoubtedly take us back to the dim, remote and unfathomed ages of Mankind in the Far Eastern countries of this World.